Muses
in
Watercolour

Rita Clements Lee

Copyright 2013
Rita Clements Lee

Cover and Illustrations
Copyright 2013
Rita Clements Lee

The moral right of the author has been asserted. All rights reserved. No part of this publication may be reproduced, stored in a retrieval system, or transmitted in any form or by any means, electronic, mechanical, photocopy, recording or otherwise, without prior written permission of the copyright owner. Nor can it be circulated in any form of binding or cover other than that in which it is published and without similar condition including this condition being imposed on a subsequent purchaser.

ISBN-13: 978-1490427089

For Karen and Stephen

Also by Rita Clements Lee

Lost in France - Paperback - eBook

The Kiss of the Sun - Paperback - eBook

http://ritaclementslee-artist.co.uk

Painting is a hobby of mine. I have no pretensions of my abilities, just the satisfaction of choosing a subject and trying to interpret it through the medium of watercolours. Artistic licence allows me to see aspects of the subject in a way that allows one to see beyond the obvious.

At the end of the day, do you feel that your painting was worth the effort. Only you can decide that. If it was, you will have a picture to treasure and you can't wait to start another one.

Rita Clements Lee.

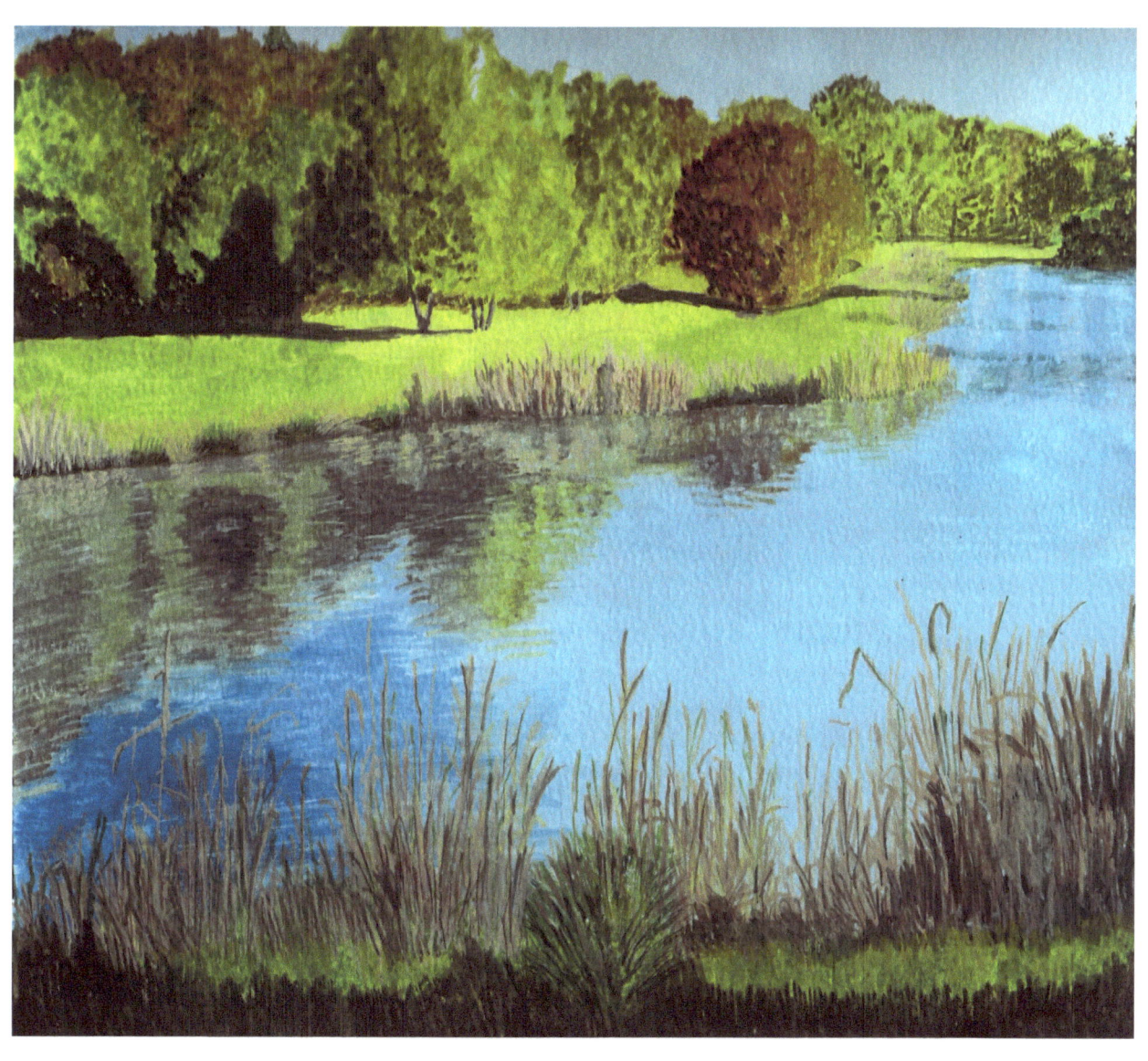

'Lakeside' - Dearne Valley Park - South Yorkshire

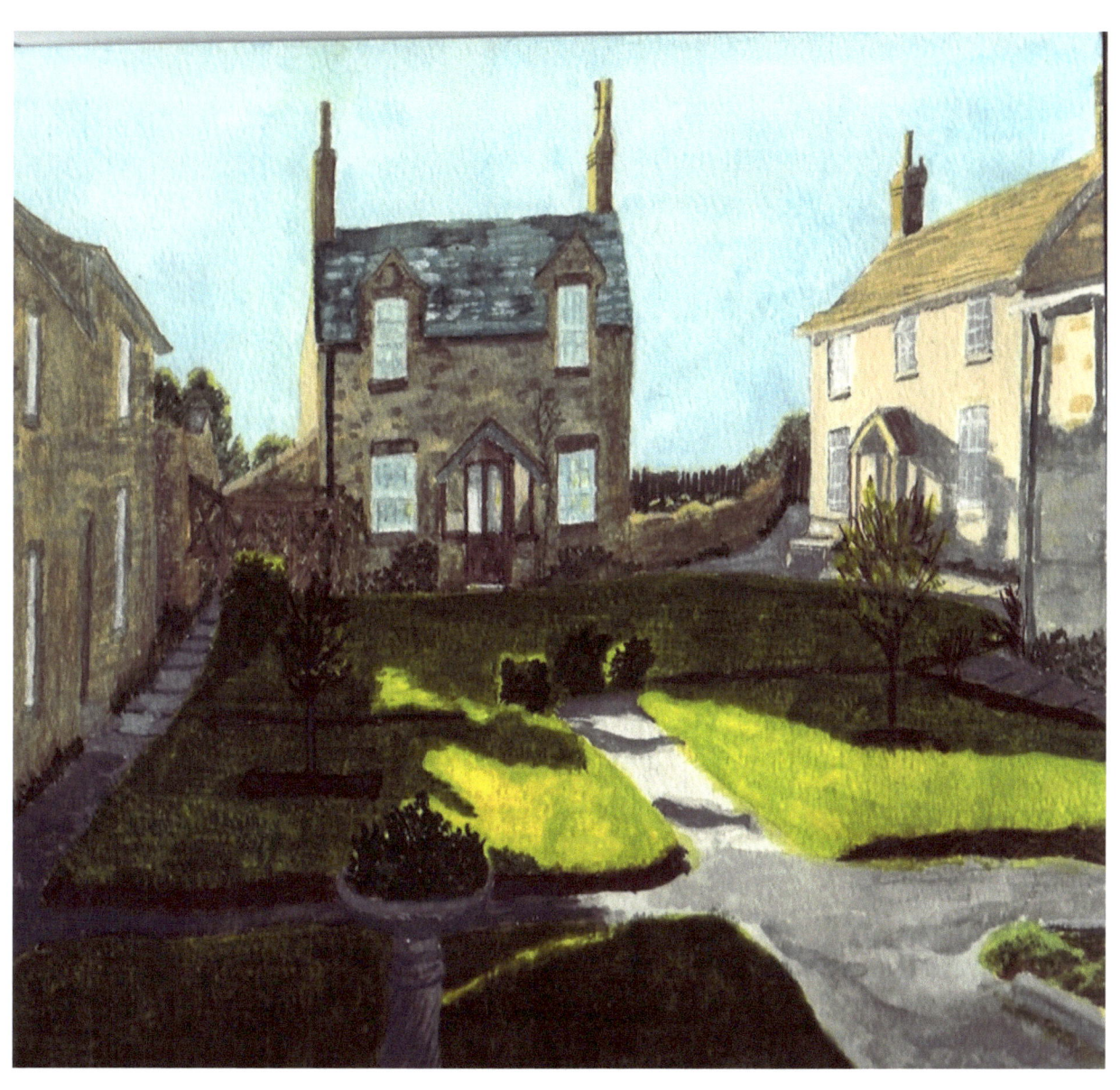

'Paradise Square' - Wentworth -South Yorkshire

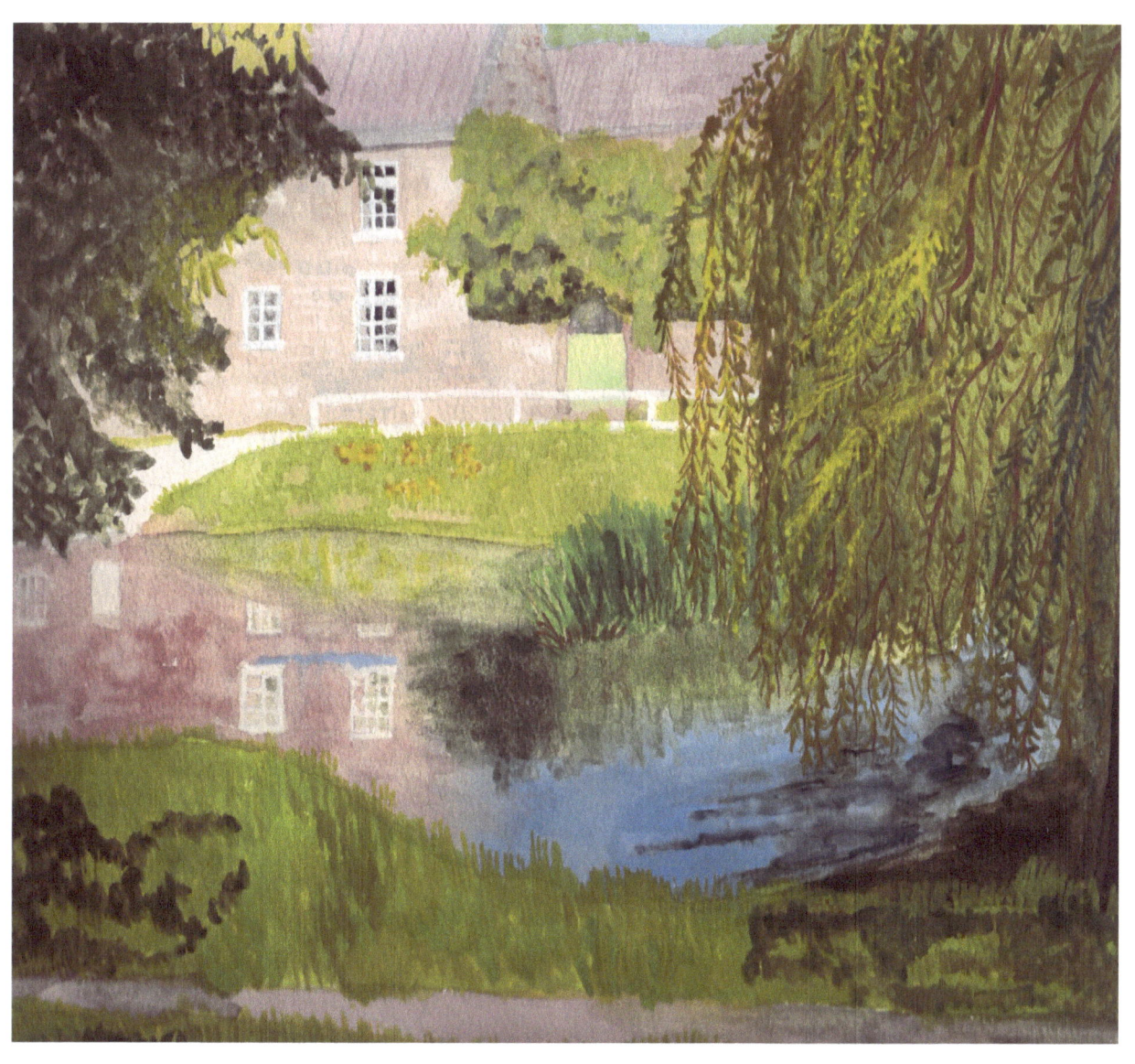

'Village Pond' - Clayton - South Yorkshire

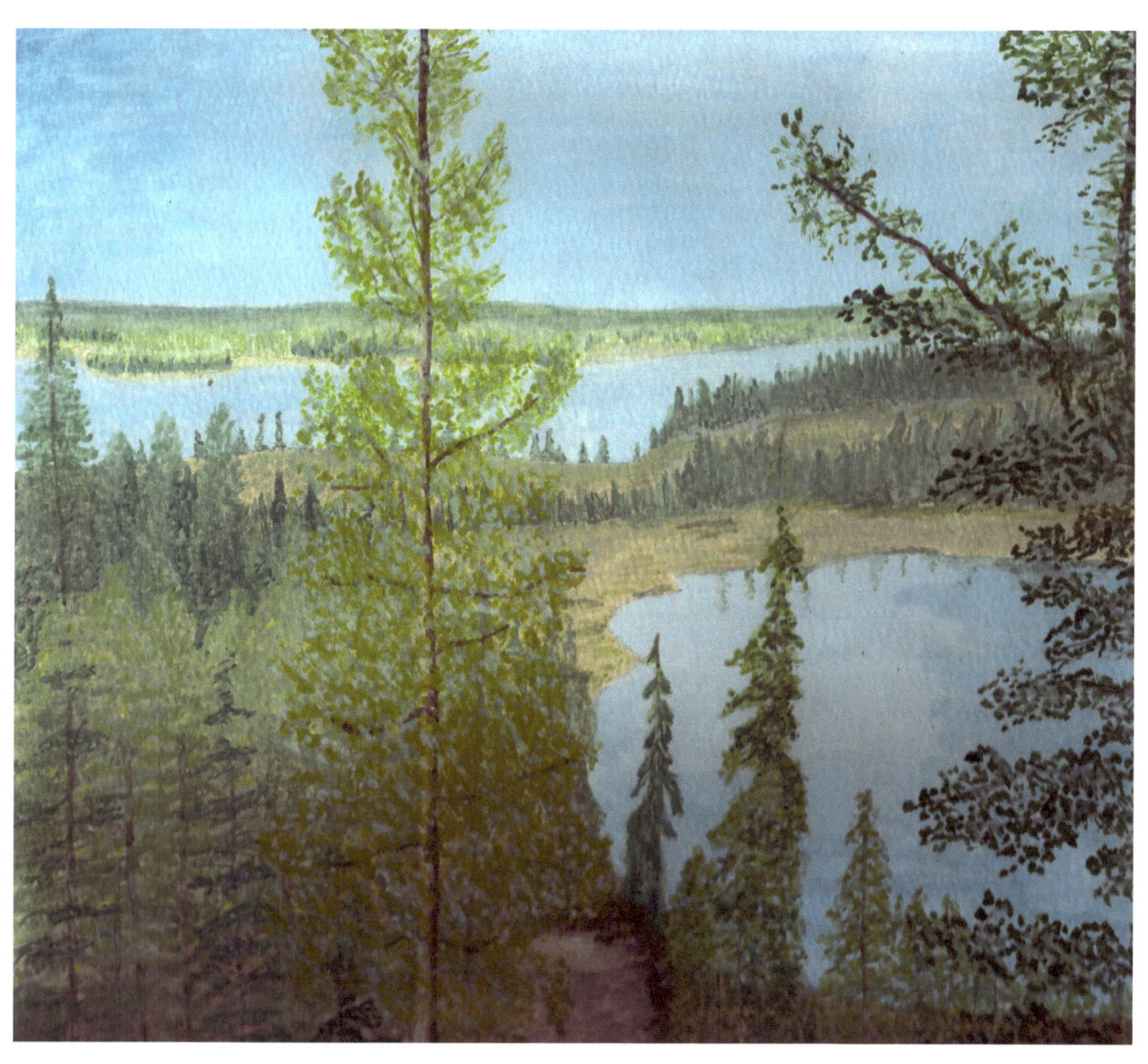

'Forest Lakes – Finland

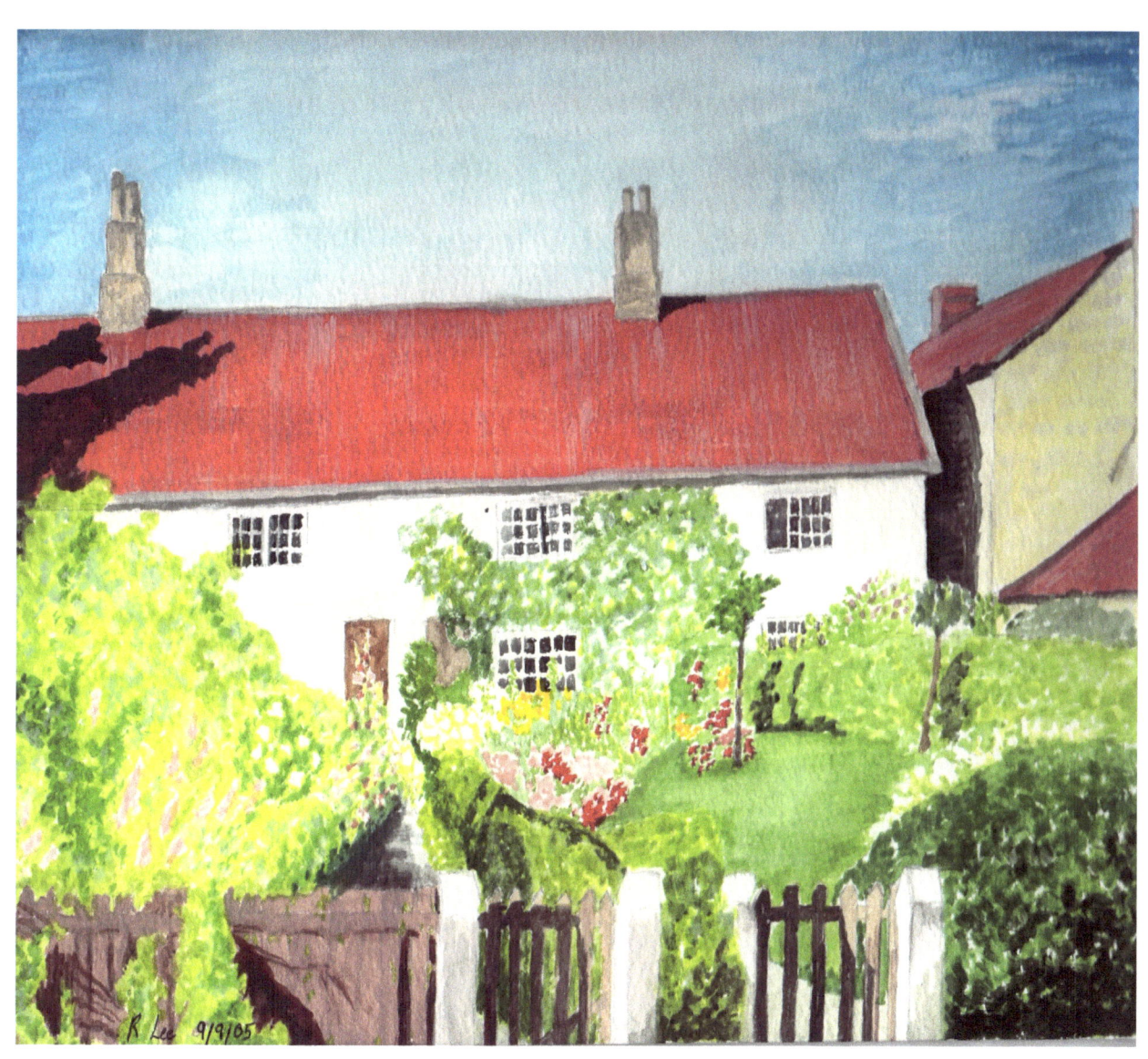

'Cottages' - Hickleton - South Yorkshire

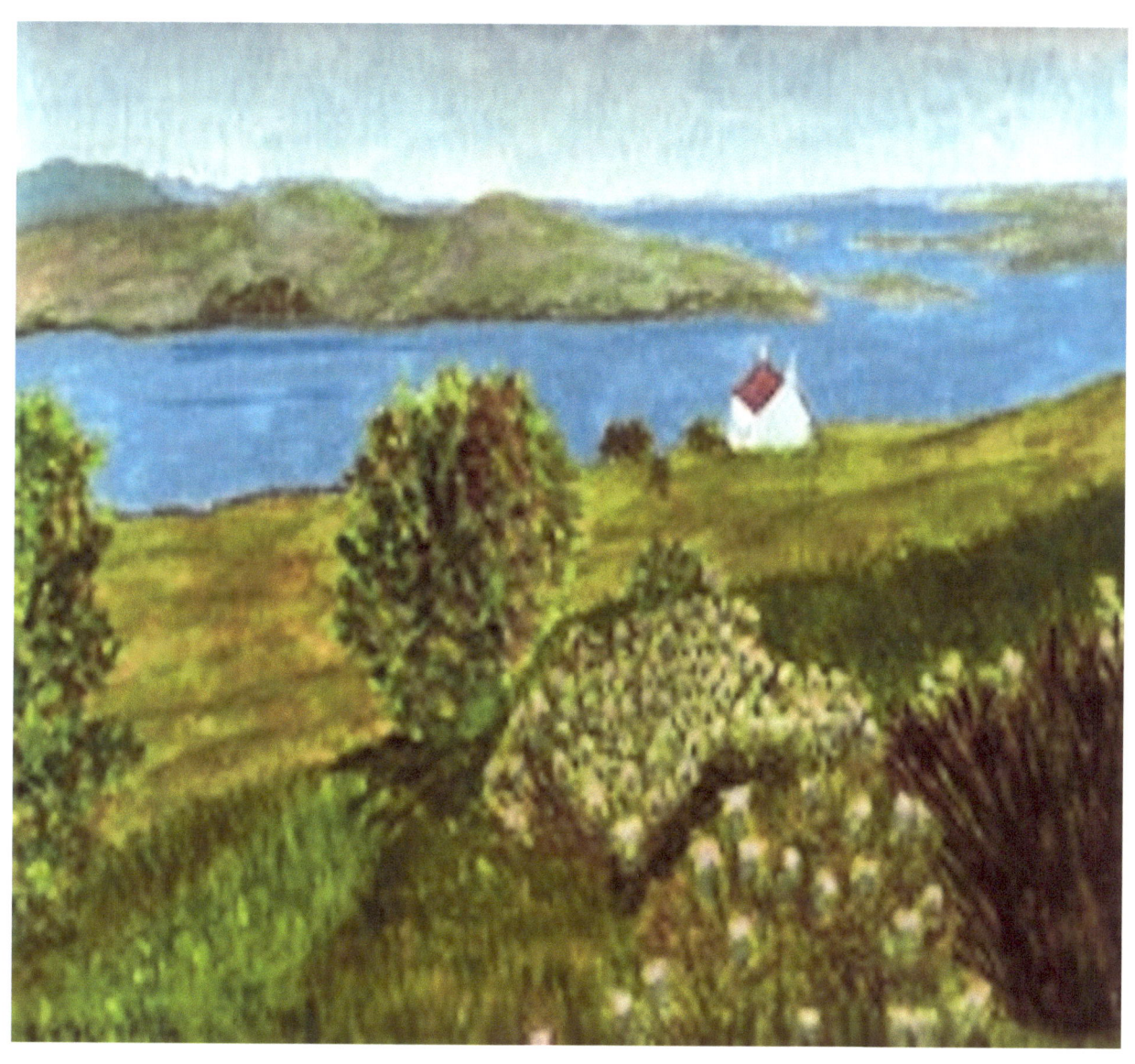

'Summer Isles' - Ullapool - Scotland

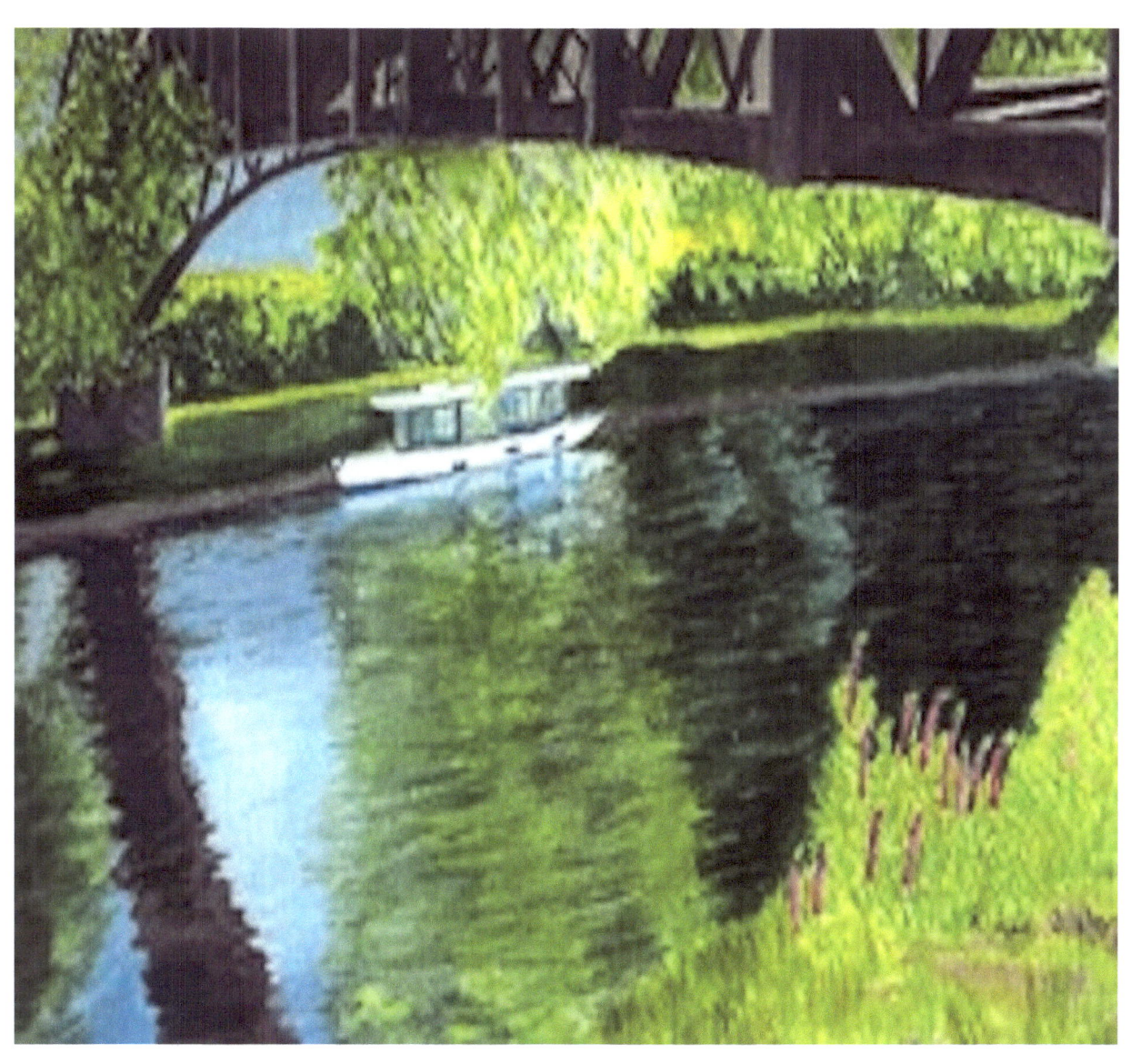

'River Avon' - Stratford-on-Avon

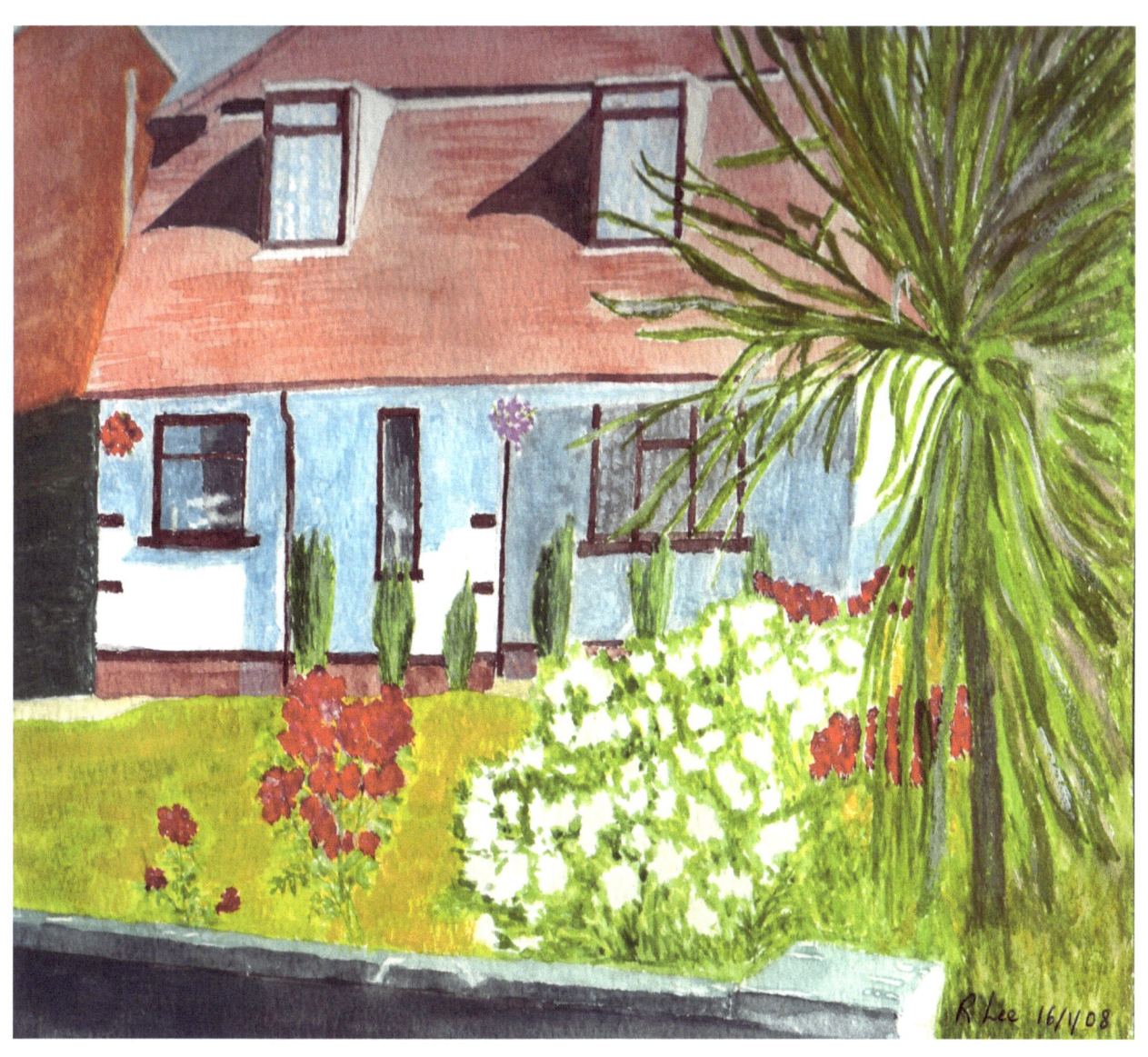

'Dove Cottage' - Great Houghton - South Yorkshire

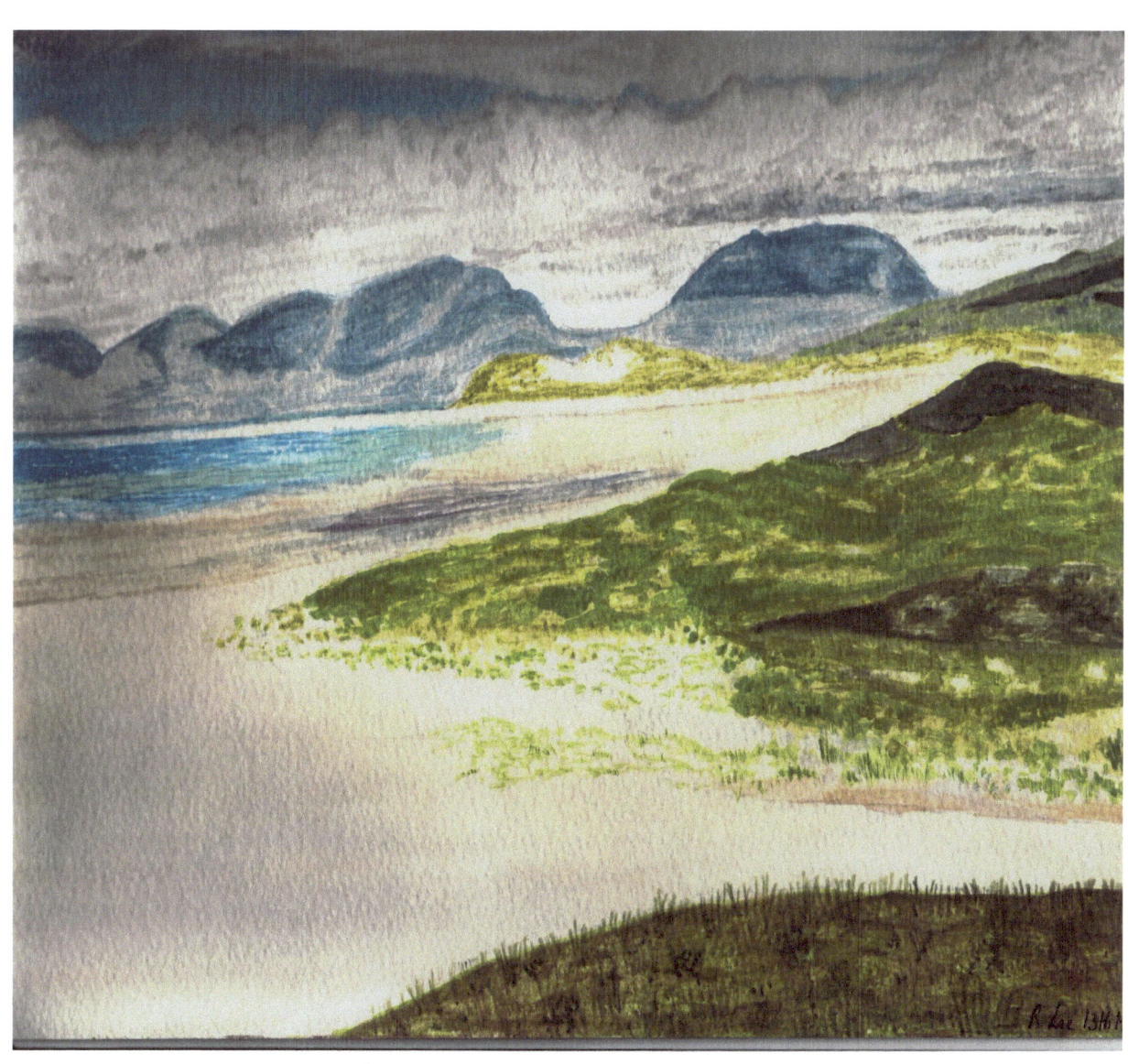

'The Strand' - Isle of Harris - Scotland

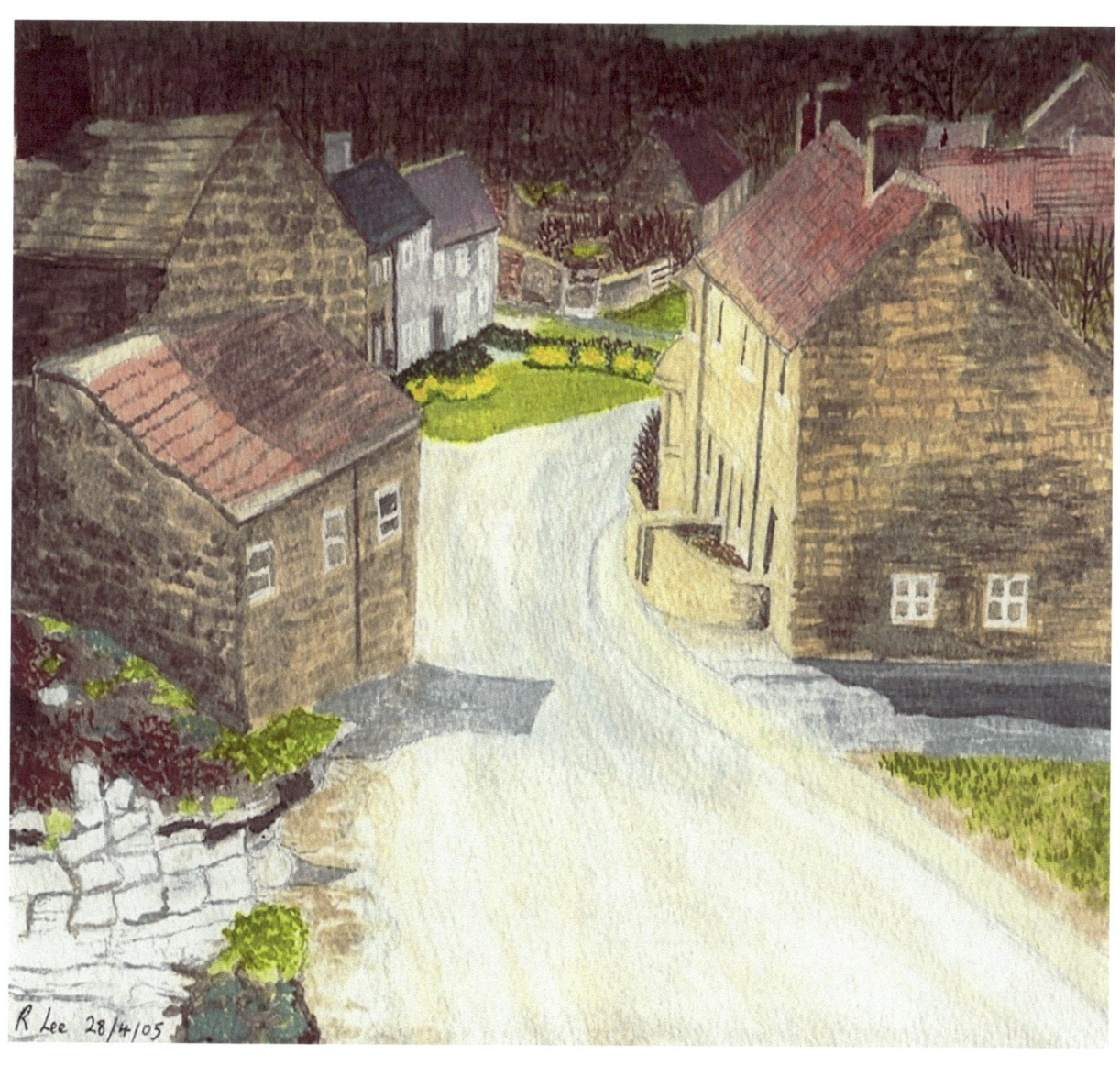

'Hooton Pagnell' - South Yorkshire

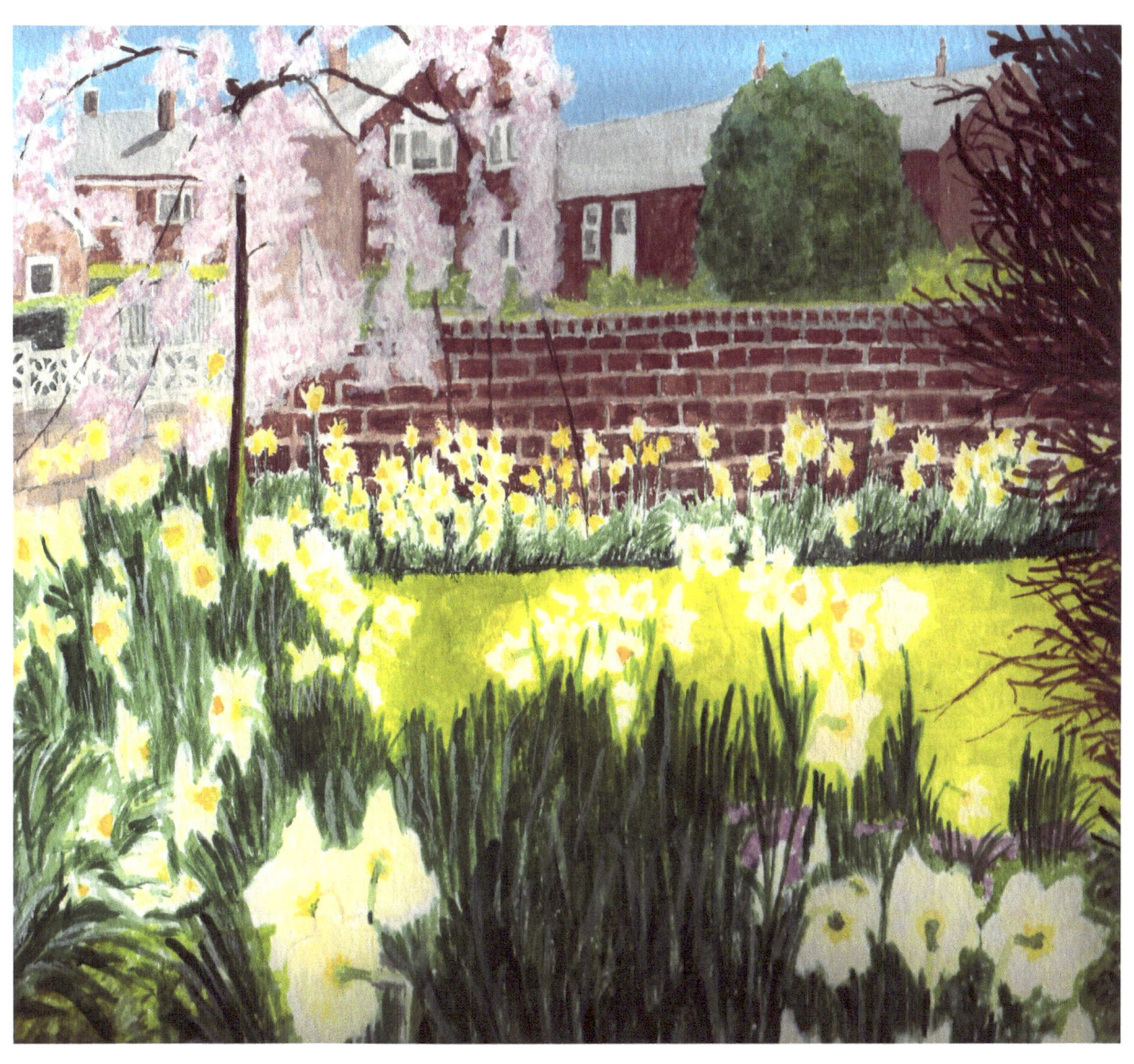

'Springtime' - Great Houghton

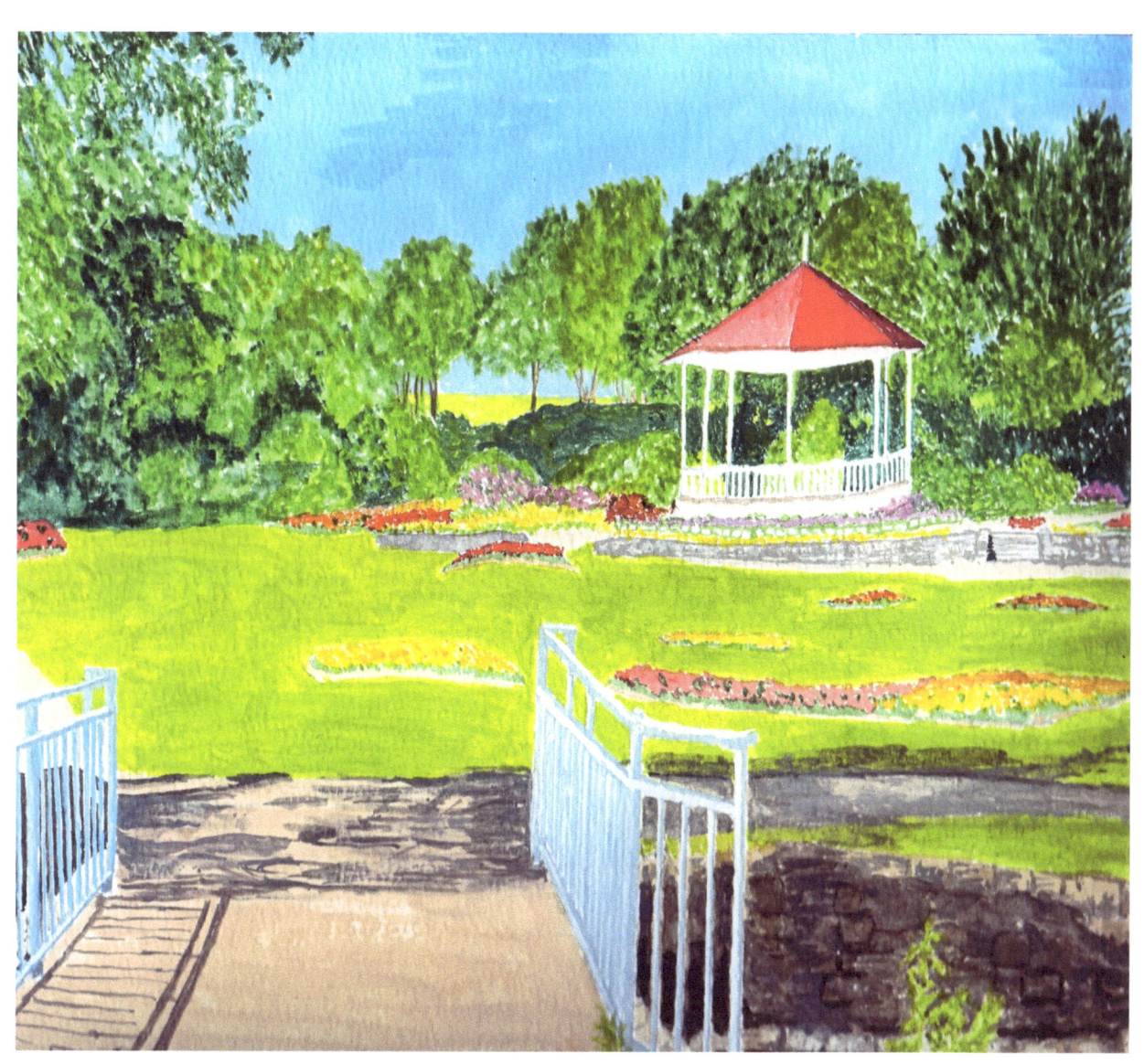

'Park View' - Elsecar - South Yorkshire

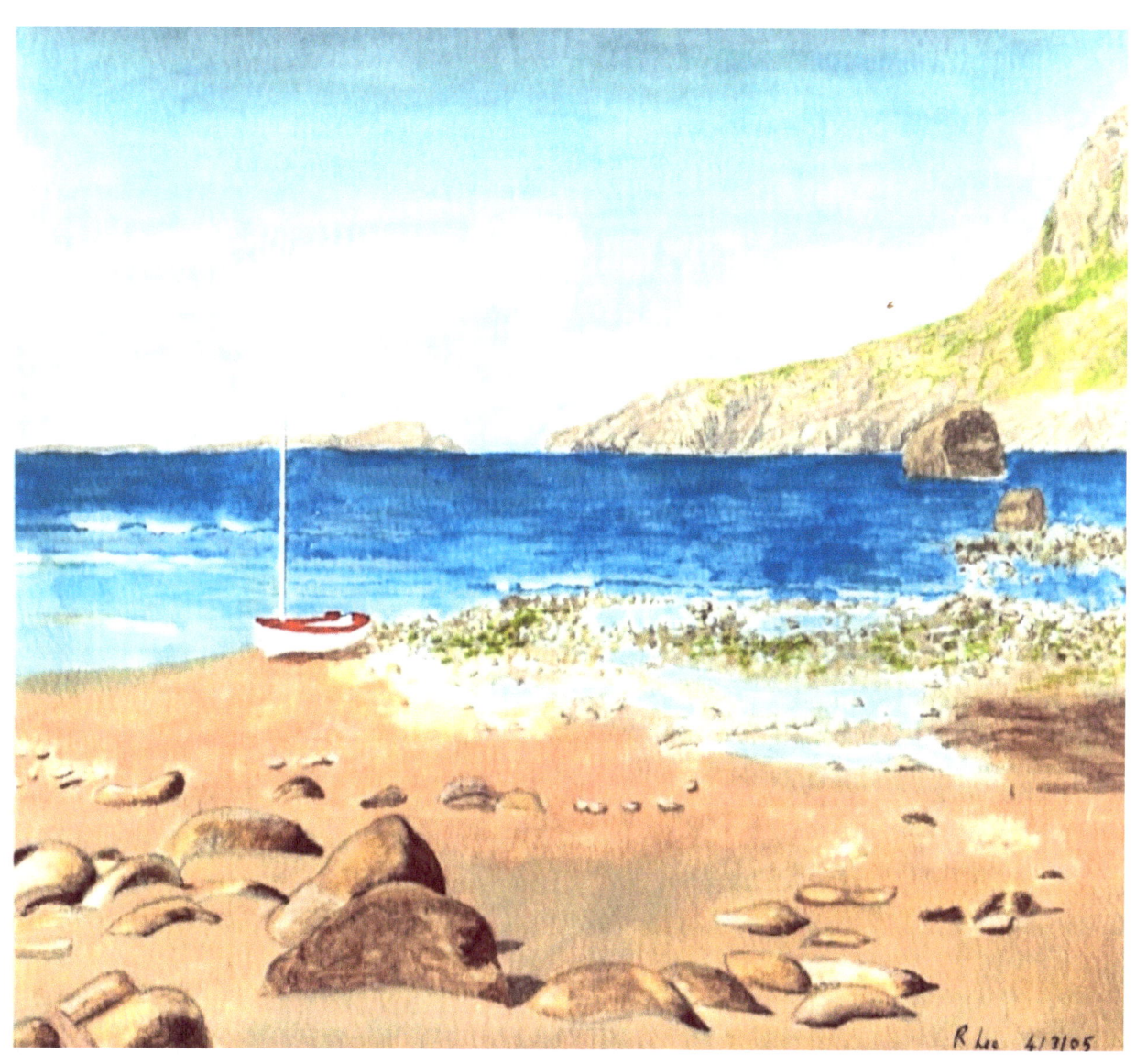

'Seashore' - Inverpolly Nature Reserve - Scotland

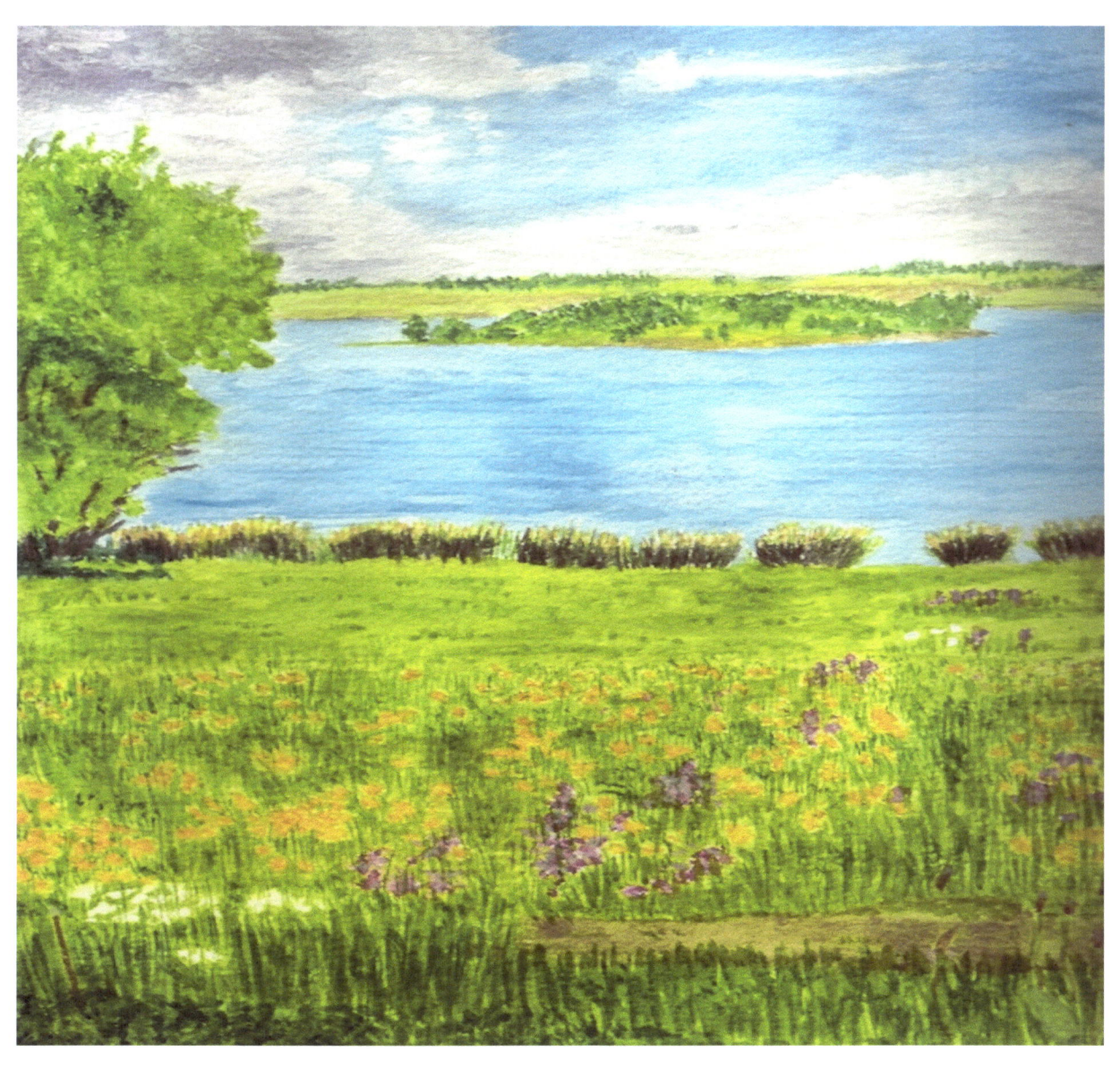

'Old Moor Wetlands' - Dearne Valley

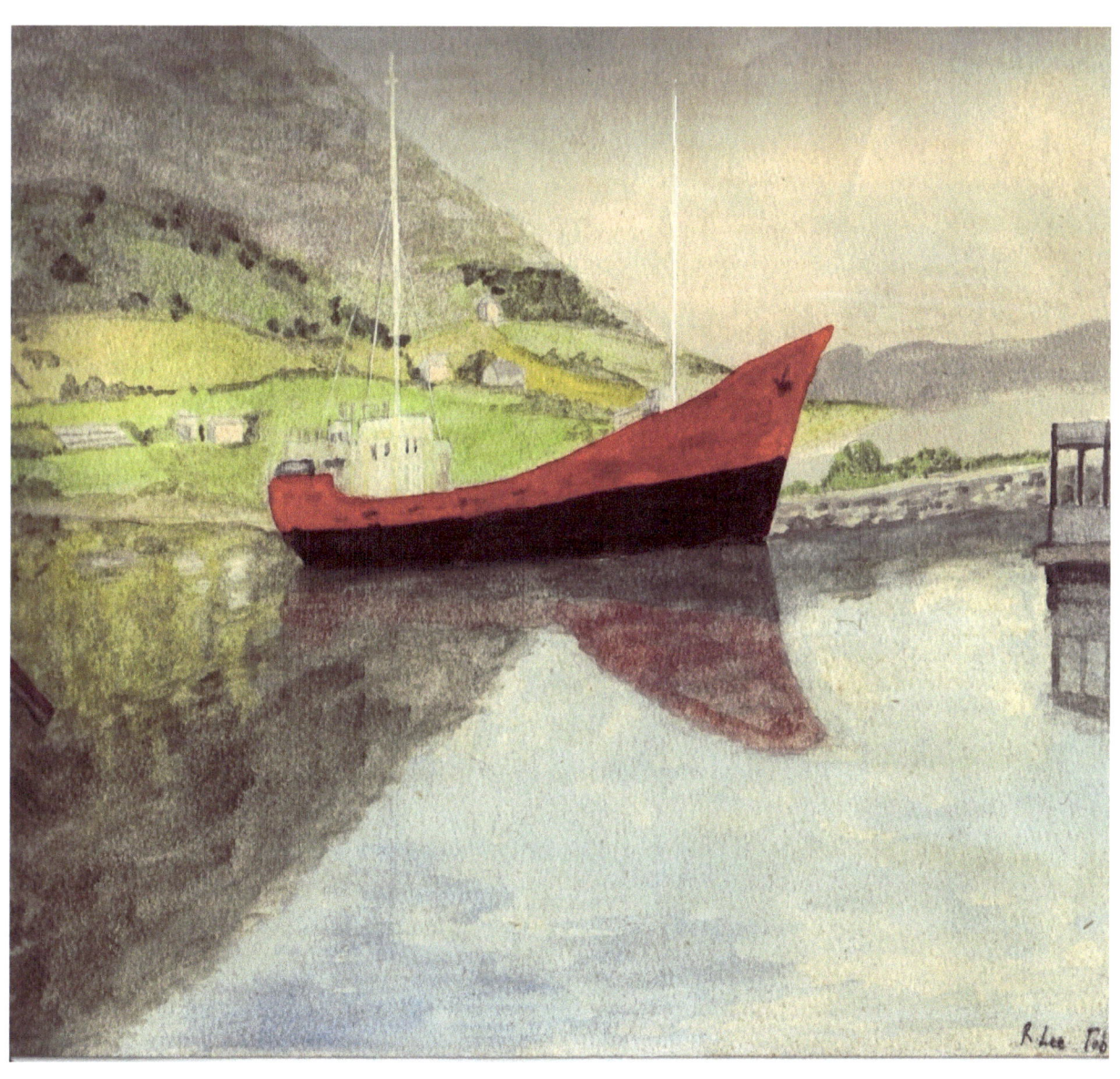

'The Mooring' - Fjord – Norway

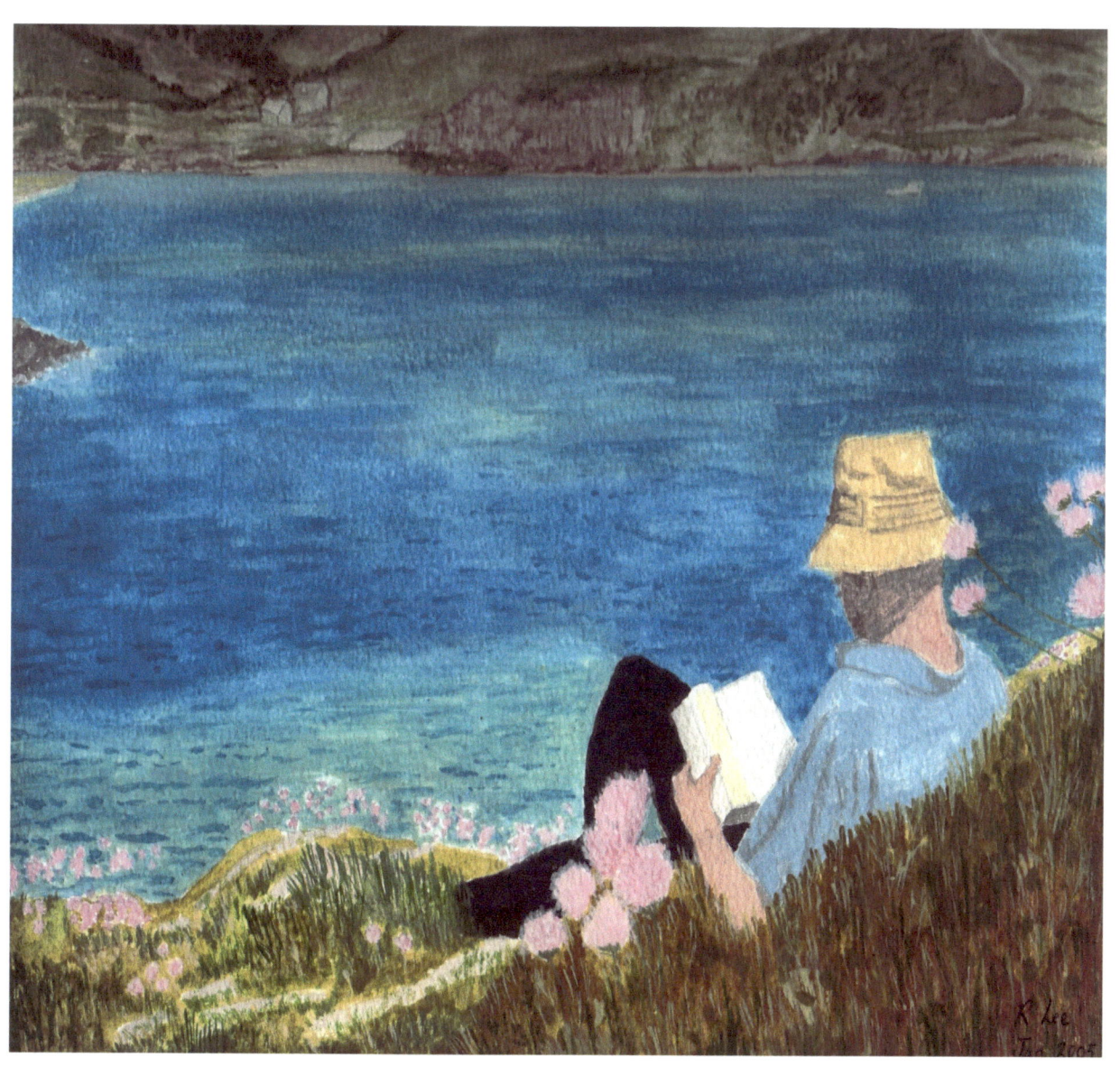

'Relaxation' - Polperro - Cornwall

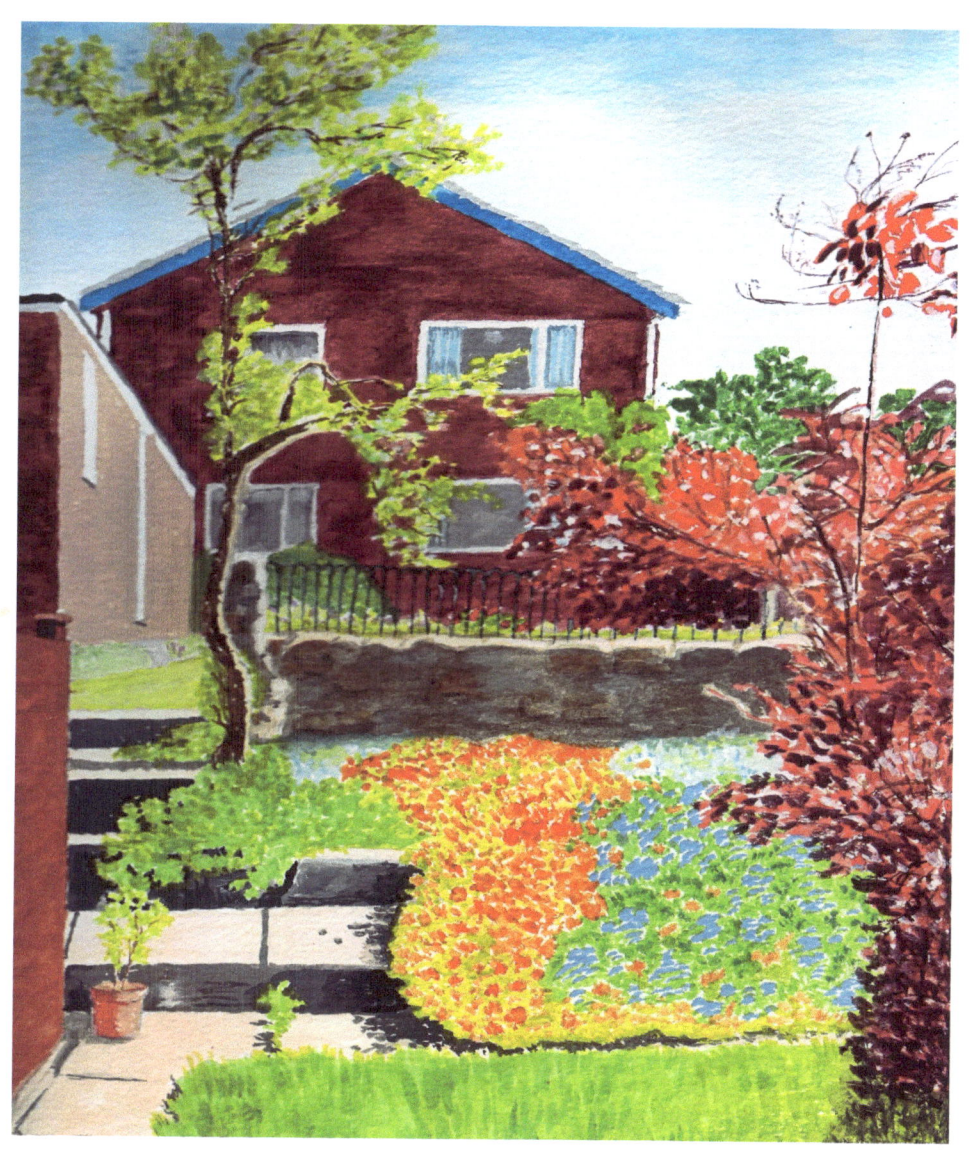

'Garden Steps' - Great Houghton

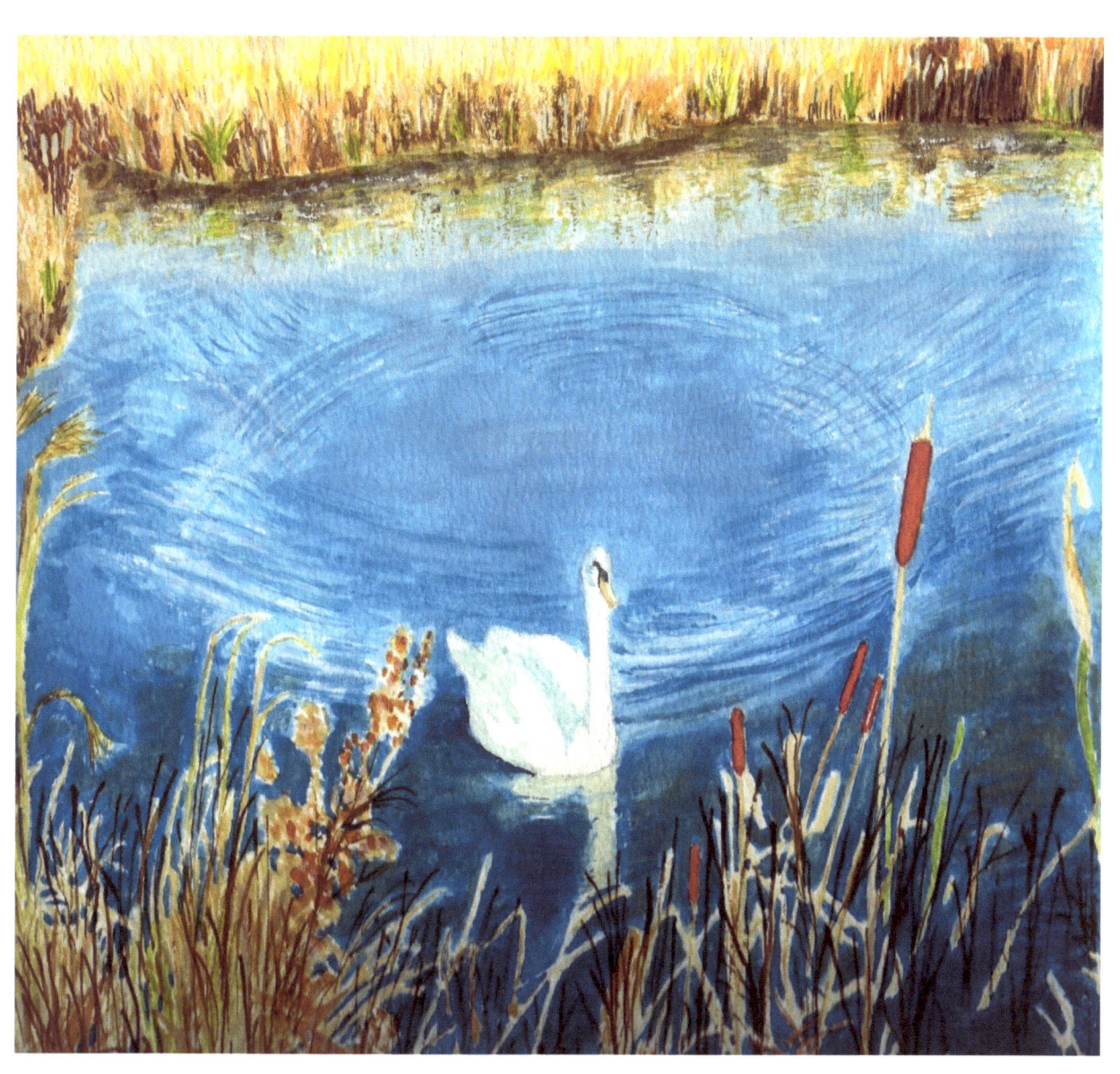

'Swan Lake' - Manvers Lake - South Yorkshire

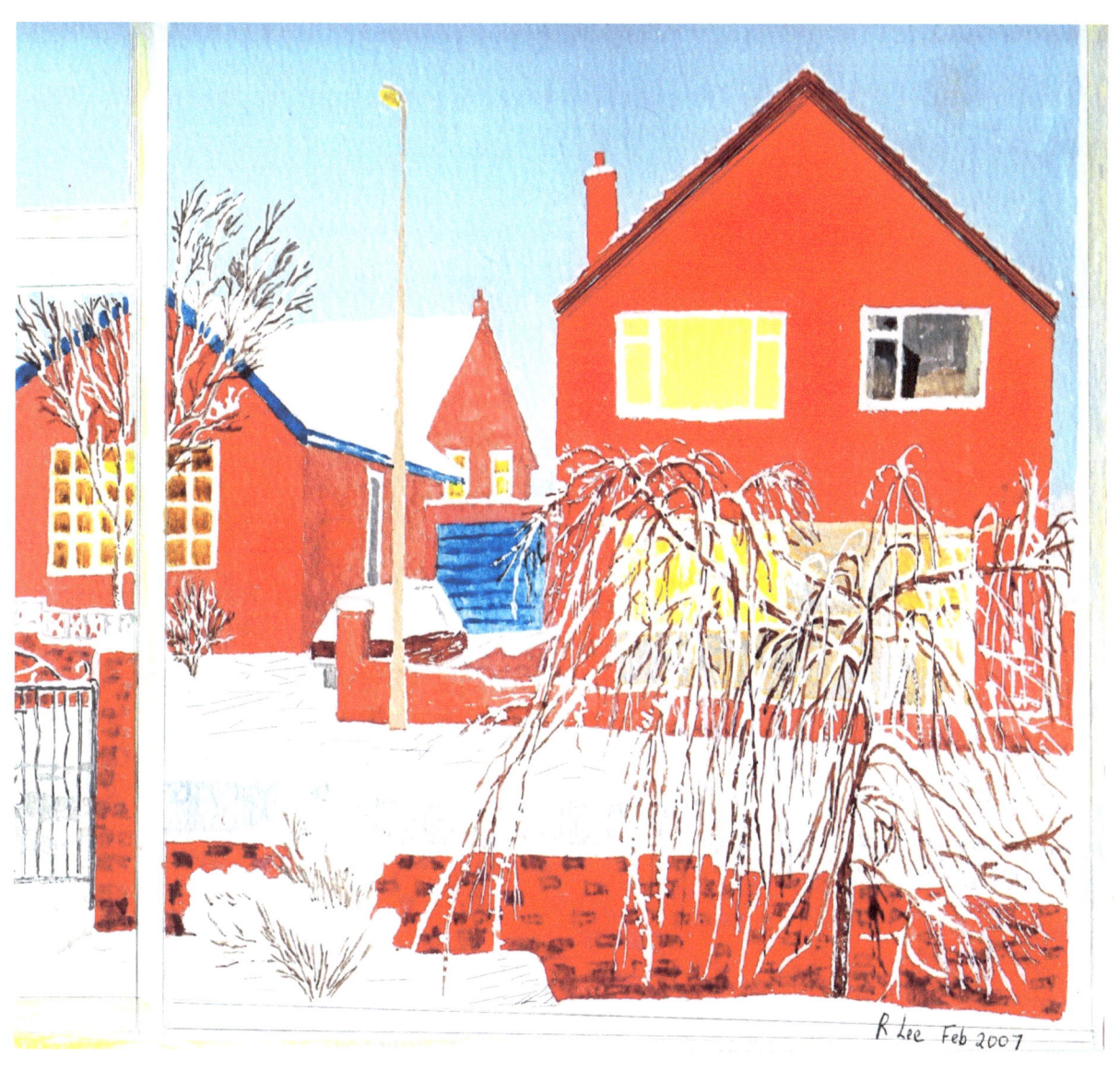

'Winter - 07' - Great Houghton

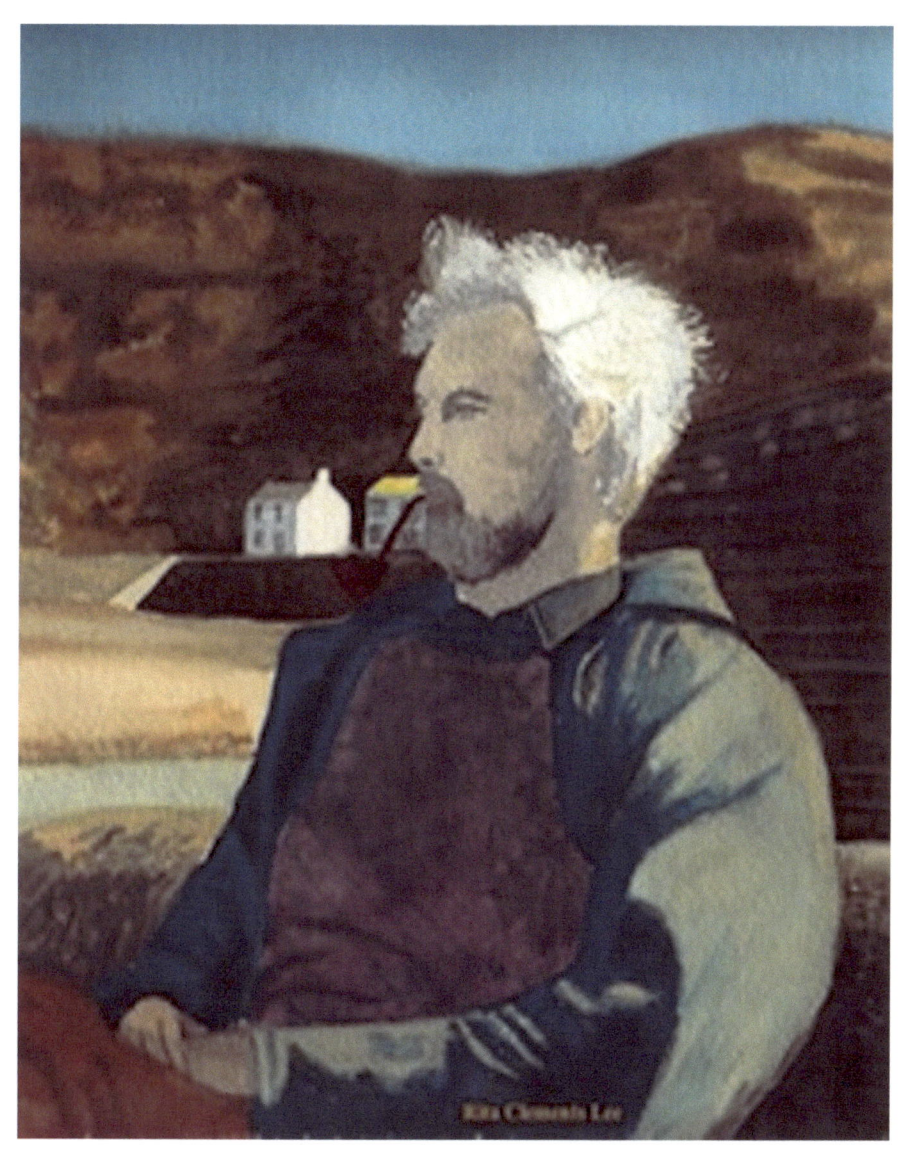

'Brian' - Staithes - North Yorkshire

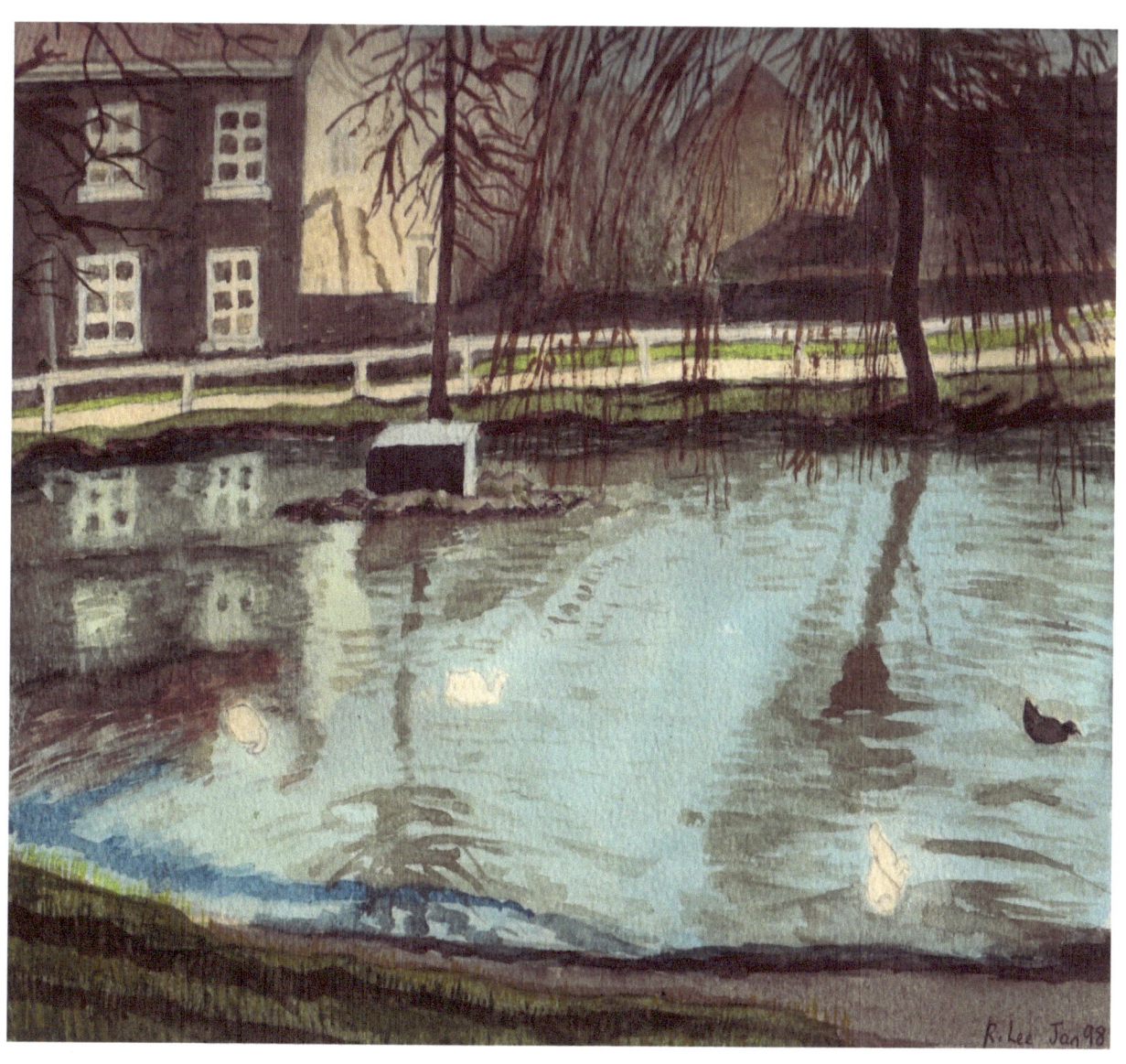

'Reflections' – Clayton – South Yorkshire

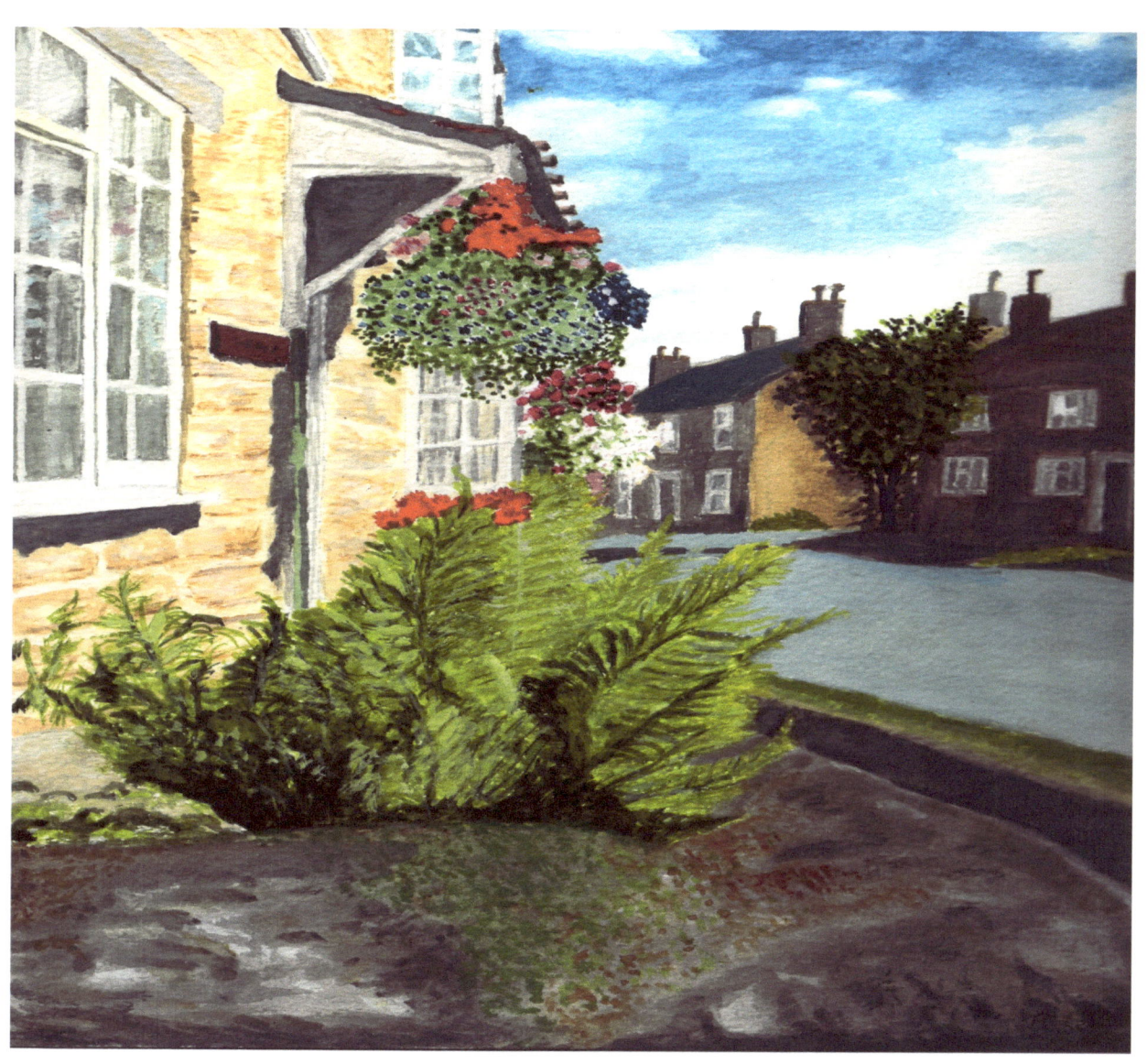

'Village Lane' - *Hutton Buscel* - *North Yorkshire*

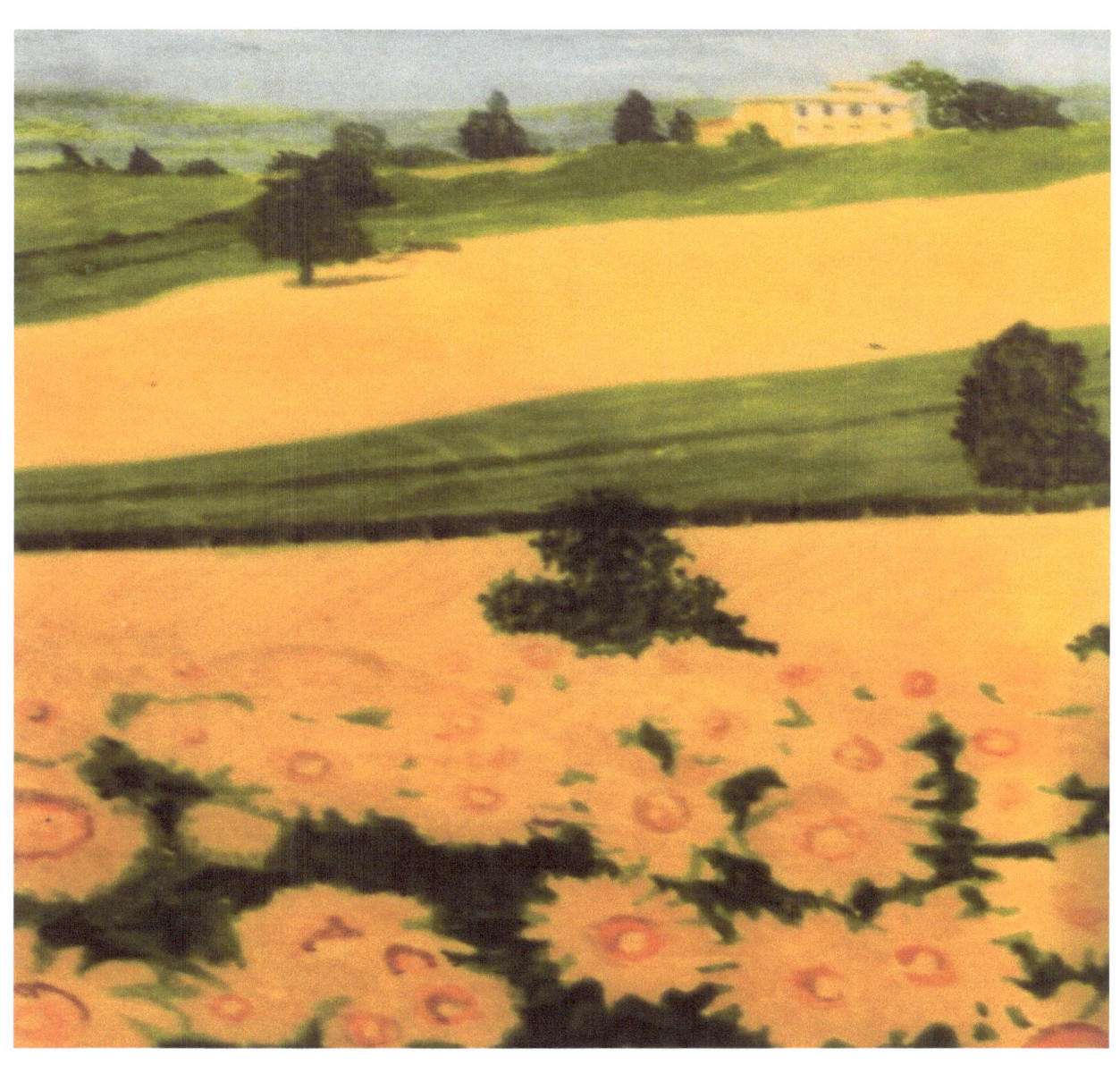

'Sunflowers' - France

www.ingramcontent.com/pod-product-compliance
Lightning Source LLC
Chambersburg PA
CBHW050815180526
45159CB00004B/1675